An Eye on the Street

An Eye on the Street
Glasgow 1968

Photographs
by
David Peat

Contributors
Alan Spence, Robin Gillanders, David Bruce, Billy Connolly

Designed and edited by Lucina Prestige

Renaissance Press

First published 2012
by
Renaissance Press
4 Warriston Cres
Edinburgh EH3 5LA
www.renaissancepress.co.uk

ISBN 978-0-9543961-3-8

Printed by Multiprint (Scotland) Limited, Seafield Road, Kirkcaldy, Fife KY1 1SR

Dedication

For Trish
Duncan and Rosie
with all my love and thanks

Acknowledgements

Even in this digital age, there is no such thing as an 'instant book'. With this one, it could be said to have had a gestation period from the steam age to the present as I was just 21 years old in 1968 when I took these photographs. To bring them to life after being hidden for over four decades has brought me into contact with some wonderful people.

I first mentioned the existence of the portfolio to Kevin and Jayne Ramage at the remarkable *Watermill Gallery* in Aberfeldy in 2006. They instantly agreed to hold an exhibition. But an exhibition needs prints and - as the films had only been developed, but never enlarged - that was the next problem.

Enter Robert Burns, one of the very last traditional dark-room printers in Scotland. Every visit to him was like Christmas as each new print appeared.

Exhibition over, talk lingered over the possibility of a book. One of the joys of Scotland is the ability to avoid the slow decision-making of large-scale organisations by seeking out small light-footed companies. The approach by the art publishers Renaissance Press led by Lucina Prestige promised speed, guidance and access to funding. They also brought to the table their own relationship with the highly knowledgeable book-printer, Eddie Ross.

We were on a roll! The chosen images had to be digitally scanned and graded and the quiet patience of Calum McKenzie has been invaluable to someone unskilled on computers.

From pictures to words. My thanks to Alan Spence and Robin Gillanders for their insightful essays. There are risks (and joys!) of opening up your work to the forensic criticism a wordsmith can bring, but both have cast fresh light on material I thought I knew well.

This book represents my earliest work, all of the images taken in Glasgow. Its publication will coincide with a major retrospective of my photography from around the world from 1970-2010 at *Street Level Photoworks* in Glasgow, under the watchful eye of Malcolm Dickson.

I have already mentioned the publishers, Renaissance Press, but one of the partners, David Bruce, deserves very special thanks. Without his energy, enthusiasm and enormous knowledge of all things photographic, there would not have developed the head of steam that has seen the book reach its destination.

Finally, as fellow passengers, my wife Trish and children, Duncan and Rosie, have brought companionship, a critical eye and support as only a family can when observing a dream become reality.

To you all - and the many other friends who have kept my belief alive, my sincere thanks.

David Peat
March 2012

With thanks to Carcanet Press for permission to publish the extract (Glasgow Sonnets) from *Collected Poems* by Edwin Morgan , pub 1996.

Introduction
by Alan Spence

David Peat's Glasgow

Looking at these photographs by David Peat, taken in Glasgow in the 1960s, I'm suddenly back there, as I often am in dreams. I grew up in Govan, post war, baby boom, and though the photos were taken in Gorbals and Maryhill, the reality was the same. My reaction is visceral - I feel it in the gut. I can smell the place - the acrid dusty smell of half-demolished buildings, the stink of stagnant puddles and blocked drains.

Edwin Morgan has a magnificent sequence of Glasgow Sonnets depicting the time and the place exactly, the Rachmanite slum landlords, the dereliction, the gutting of entire neighbourhoods, the sense of hope in the move out, to peripheral schemes, and up, to towering high-rise blocks. *Hackles on puddles rise, old mattresses / puff briefly and subside. Play-fortresses / of bric-a-brac spill out some ash. / Four storeys have no windows left to smash...*

Other great photographers - George Oliver, Oscar Marzaroli - recorded, preserved, interpreted this world, these changes, and David Peat's work stands alongside the best. In this series (and there does seem to be a narrative to it, like stills from one of his documentary films) he sets the scene, shows us the ravaged landscape and peoples it with characters. And almost without exception, those characters are children. Not downtrodden or dispossessed, they inhabit the scene and make it their own. They look out at us, resilient, inquisitive, gallus.

Peat excelled at this kind of street portrait (and perhaps there's scope for another book showing his output in an international context) and it takes a rare talent to make it work. There's the unerring eye and sense of timing – the right moment, the action caught, randomness structured. He makes it look effortlessly natural, but there's artifice too. (As Ansel Adams put it, 'Chance favours the prepared mind.') There's an almost cinematic framing of the scene and a storyboarding, a narrative flow to the images. There's also a complicity with the subjects, an obvious empathy, whether he's catching them in action (and at wild or mysterious play) or posing, ironic, in imitation of formal portraiture. Some are reminiscent of Joan Eardley's wonderful paintings of Glasgow street kids from the 1950s, in their composition, the use of graffiti, the way the children just *are*. These kids are *alive*, in all their befuddlement and wonder, their energy and vigour and sheer devilment (girls as well as boys).

And it's all set against this backdrop, a new blitz leading to overspill and relocation in the schemes, this community broken up and dispersed, the city centre re-imagined in flyovers and monoliths. It's no accident that the last image – twin towers – shows two of those blocks under construction. Onward and upward, into what? And is it my imagination, or does the jagged hole in a window, a couple of pages earlier, look like a map of Scotland? Chance had favoured the prepared mind - David Peat caught the moment, before it disappeared.

Vote Progressive
by Robin Gillanders

I can't remember who it was, but a photography teacher I once knew suggested that, within the context of a students' critique, the first step in analysing a photograph, or series of photographs, might be first to describe, quite prosaically, what is *in* the picture.

This is relatively straightforward in this selection of David Peat's work since there are so many common elements here: babies and children of course: boys with sticks and playful girls. There is only one solitary adult in the whole series. And then slums, demolition, broken windows, graffiti, detritus.

The second stage is to describe these elements and consider what they might *represent*; what the work is *about*. We are *shown* decay and poverty certainly. But the work seems to be *about* community, resilience, innocence, cheerfulness and optimism.

Like all documentary photographs, they become more interesting and valuable with the passing of time. These images of the Gorbals and Maryhill are now almost half a century old and at the simplest level they tell us what people looked like then, how they dressed where they lived and – to an extent – how they lived. They are then, a piece of social history. They also invite conjecture about what the photograph can't tell us. How did these kids feel about the life they lived? Where are they now and what are they doing?

David Peat was primarily a documentary film-maker who continually made photographs in the street over the last few decades. To say that the pictures were made as incidental to his professional moving image work is not to belittle them. When he began to exhibit his work some years ago it became clear that he had a very particular vision: a precise sense of frame and form certainly; a finely judged anticipation of 'the moment' definitely. These are the quintessential and unique skills of 'straight' photography. They are skills that can be fine-tuned with experience, but cannot be taught. Peat's photographs have all the more authority as historical documents and superb exemplars of the art for not having been tinged with any computer interventions.

Peat displayed a film-maker's sensibilities to narrative and sequence. In one series of photographs, he moves from the general to the particular as he communicates the experience of encounter: of approaching grim and crumbling tenements to see two prams with babies entertaining each other in the apparent absence of adults. In another sequence a young boy takes his responsibilities seriously as he foregoes play – or has perhaps outgrown play – to set up his stall to sell oranges.

The sequence progresses to unpeopled urban decay: to demolition and the building of the notorious high rise flats that were to re-house, with a ray of optimism, the people from the 'slums'. Ironically these have now in turn been demolished.

These photographs were made for the purest of reasons – not for fame or remuneration, but from the pure and personal motivation of someone who exudes human empathy. This is at the heart of the work. See for yourself.

Camera on the Street
by David Bruce

By making his images of the lively streets of Glasgow in the 1960s, David Peat became part of a practice almost as old as photography itself.

We do not know the name of the first person to be photographed in a street, but we do know where and when that image was made. The man was standing still; had he not been, his image would not have registered, such was the length of exposure required to make a Daguerreotype. He was in the Boulevard du Temple in Paris in 1839 having his boots blacked and while all the hundreds of people around him were in movement and therefore invisible to the camera, he became unknowingly immortal.

Most of David Peat's subjects were not known by name either, although a few have come forward to recognise their childhood selves; and not all were as unconscious of the photographer's presence as was the monsieur in the Boulevard du Temple. But the principle remains the same. With or without the subject's conscious consent, the photographer of the street scene seizes the moment in time and in a public space.

Technology has always been a major factor in determining the relationship between photographer and subject. Louis Jacques Mandé Daguerre's camera on its tripod high in the window of a Paris tenement and the hand-held 35mm Leica of 1925, were of the same species, but their capacities to engage with life on the streets were entirely different. Nineteenth-century street photographs by Hill and Adamson in Edinburgh, Annan in Glasgow, or John Thomson in London required a considerable degree of organisation and on-the-spot manipulation and they could not be made instantly or clandestinely.

Spontaneous, informal photographic capture only became possible much later. When it did, it unleashed the genius of Atget, Lartigue, Kertész, Moholy-Nagy, Doisneau, Cartier-Bresson and many others, and that was just in Daguerre's Paris. Equally, New York has enjoyed its photography on the street from Weegee and Elliott Erwitt to Bruce Davidson and William Klein; and much the same could be said of other cities and photographers around the world.

Our photographic perception of Glasgow has been similarly enriched, but paradoxically by the very poverty of certain areas of the city, uncomfortable as that might seem. As Gorbals and some other areas reached the end of their physical and social viability, they attracted photographers of exceptional ability who found that the very distress of the urban context highlighted the humanity of those who lived there.

Even before the demolitions began, Margaret Watkins, Humphrey Spender, Bert Hardy and Bill Brandt had made great work there. By the 1960s when the clearances were fully underway and long-established communities in process of dispersal, they had been joined by Oscar Marzaroli, Joseph McKenzie, Roger Mayne, George Oliver, Harry Benson and David Peat.

In truth, the portrait of Glasgow that emerges, the souvenir of a time not so very long past, wonderfully records for ever the humanity of the photographers, just as much as it does of their subjects.

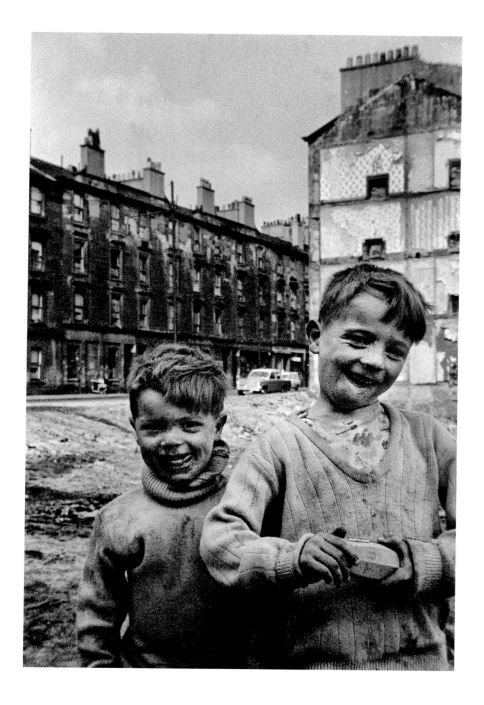

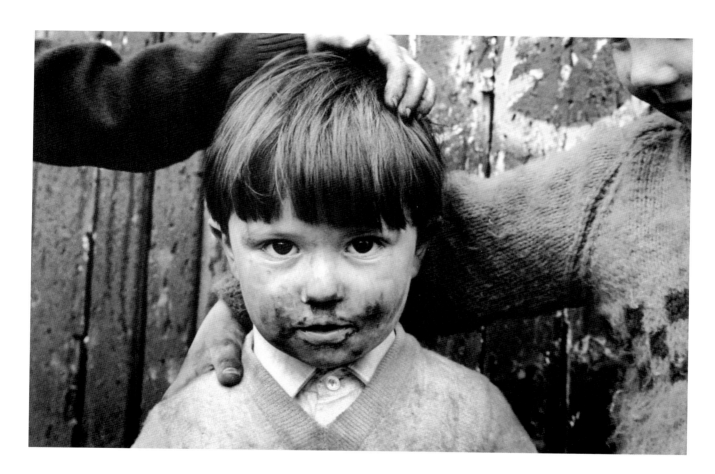

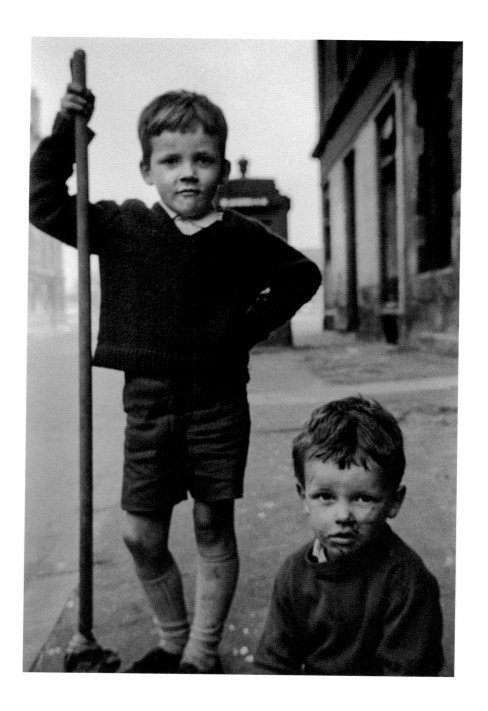

Gorbals 1968

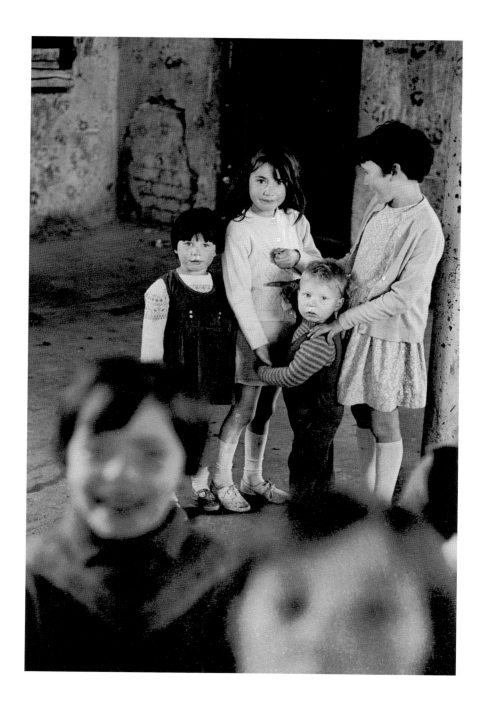

Gorbals boy

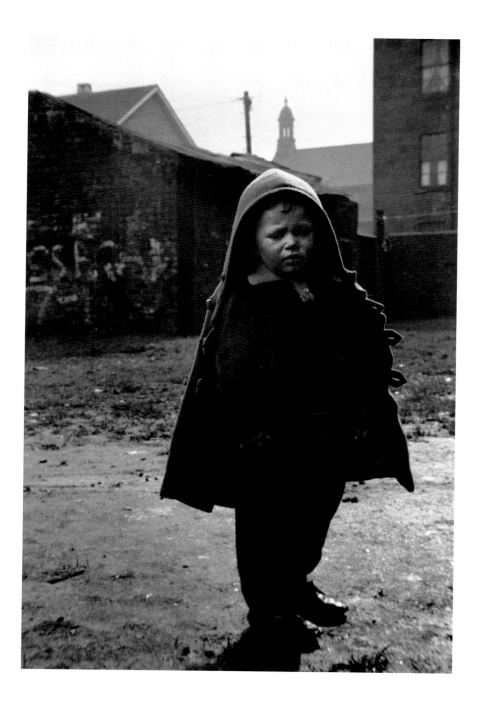

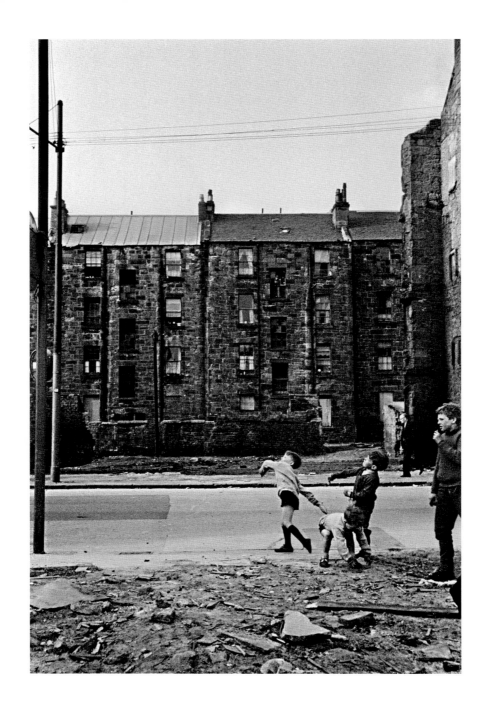

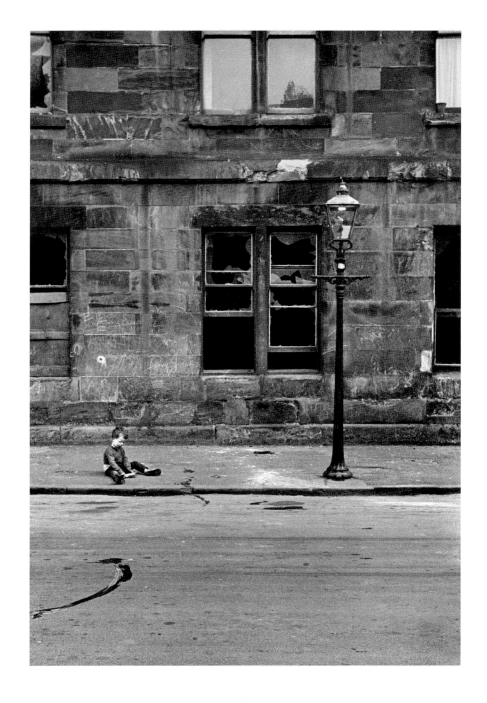

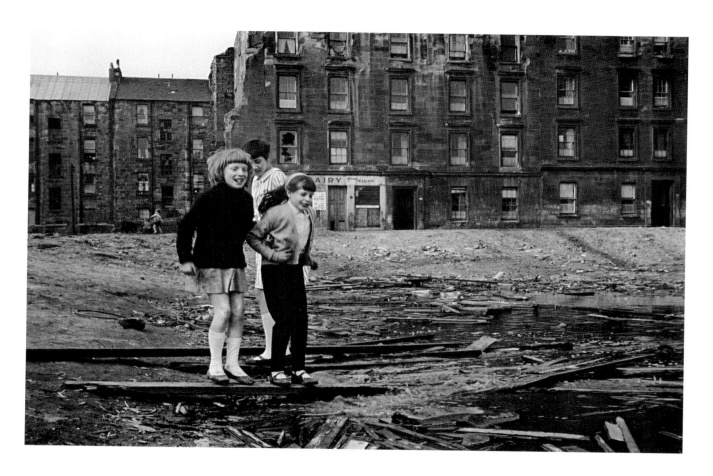

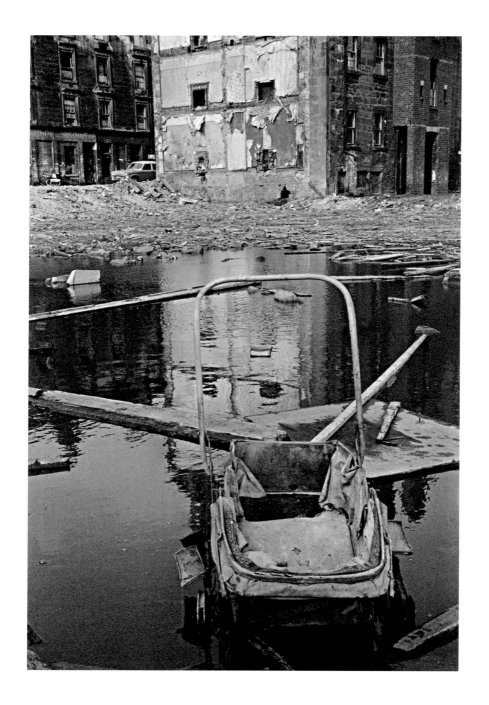

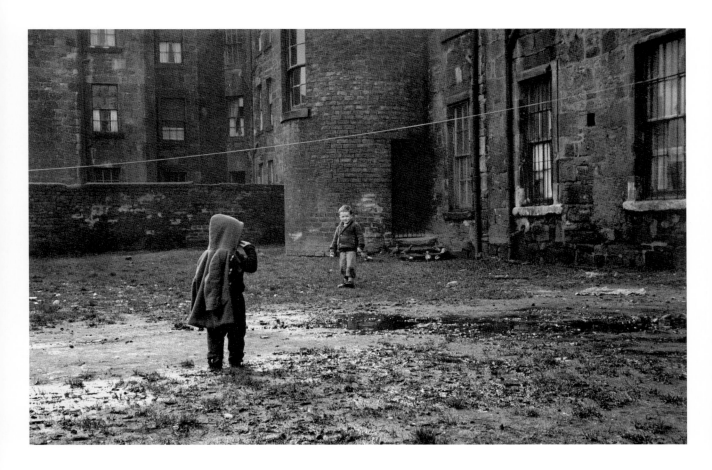

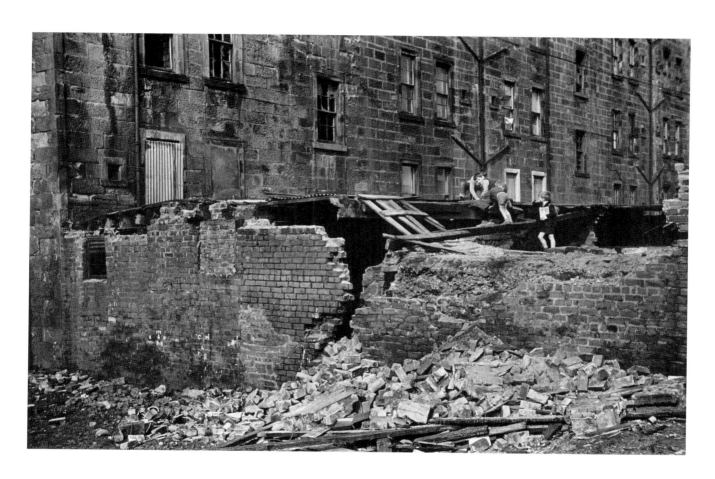

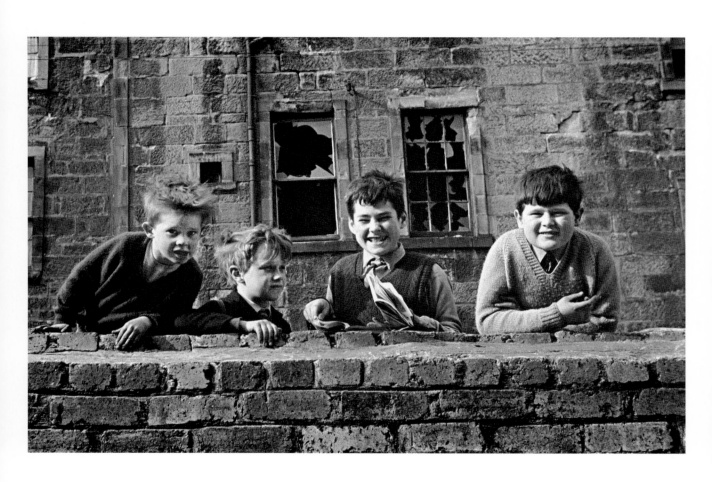

Four Gorbals boys

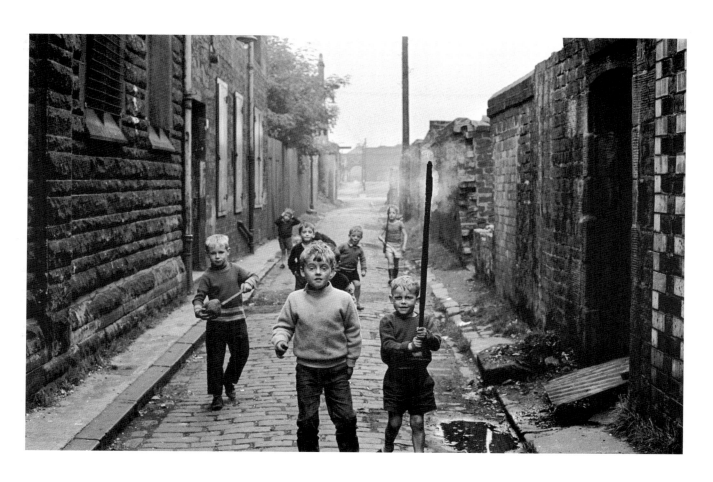

Back lane in the Gorbals

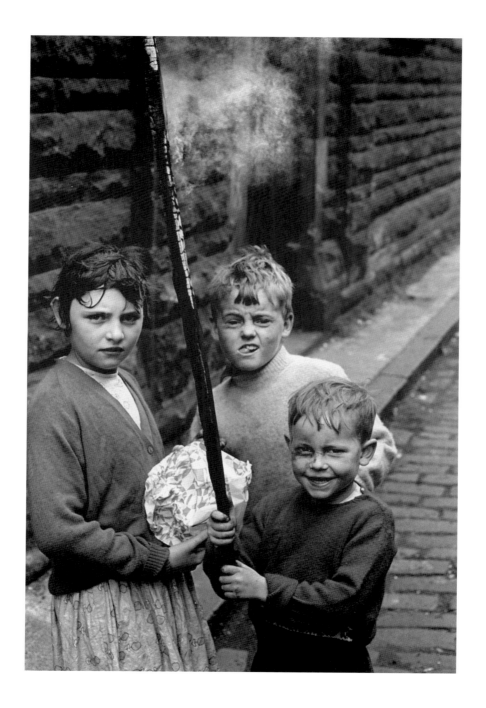

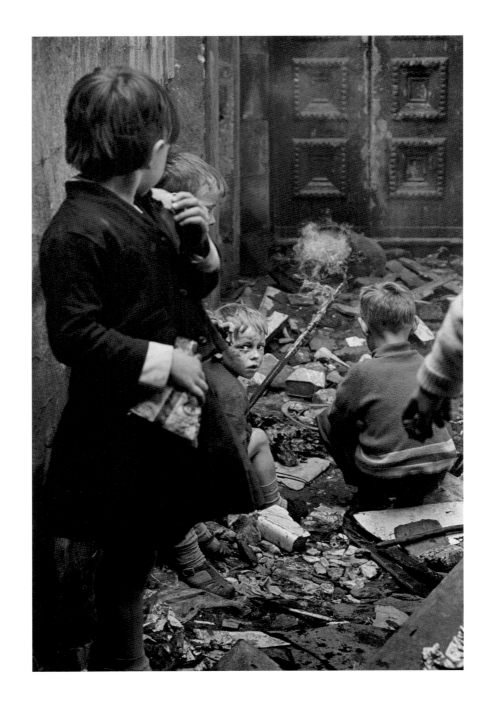

Back tenement in the Gorbals 1968

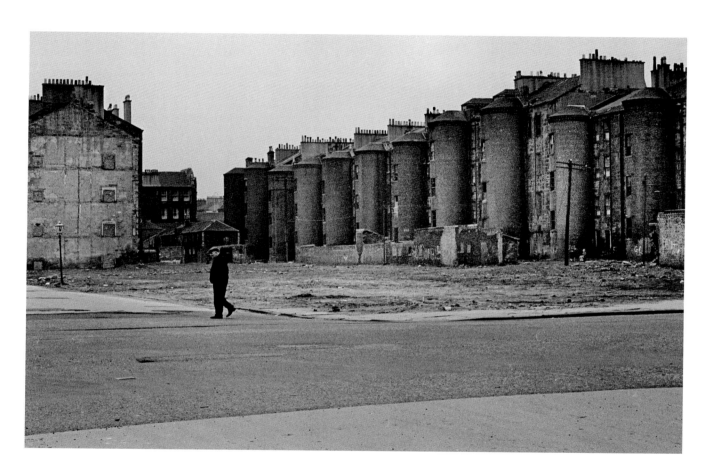

Back court, Gorbals

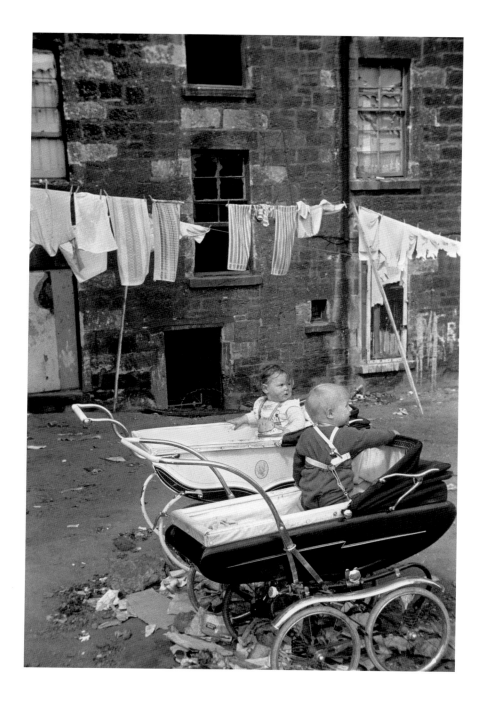

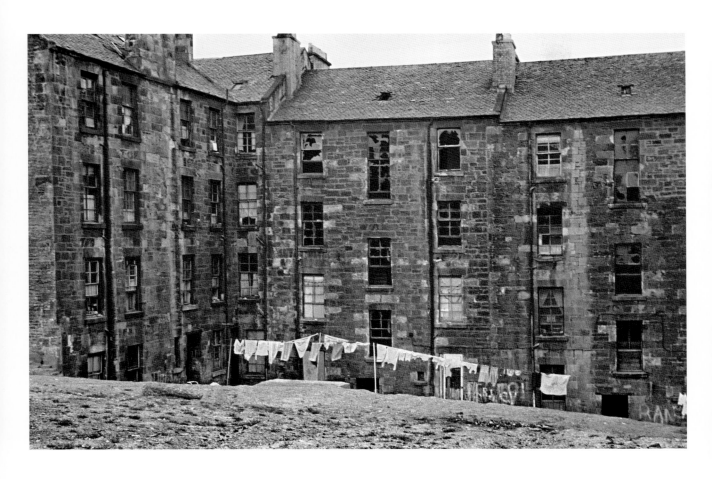

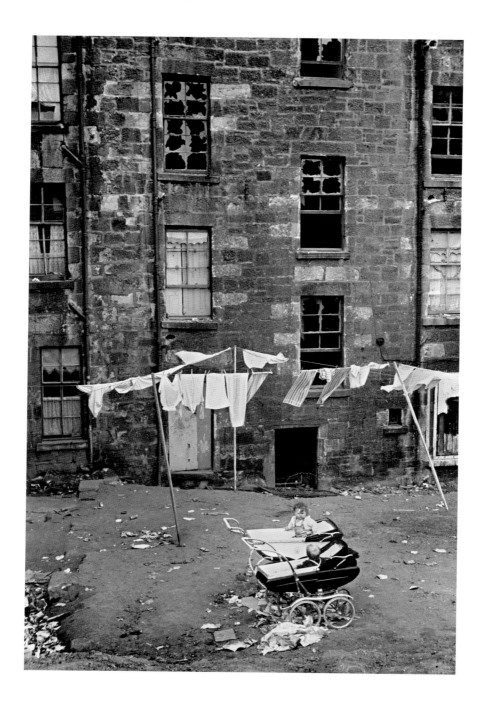

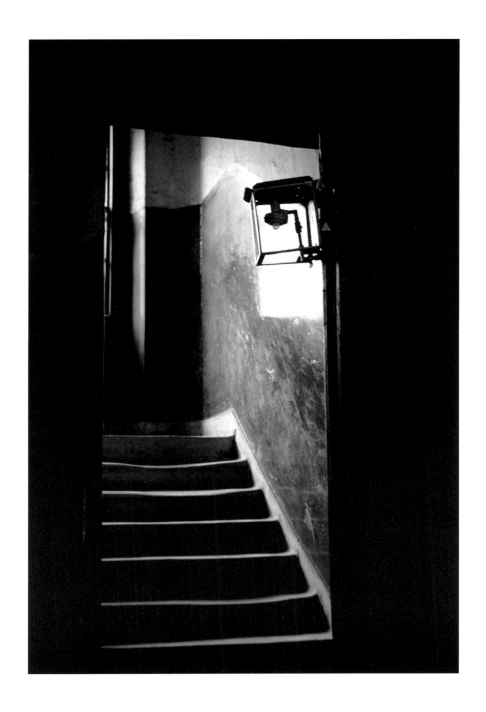

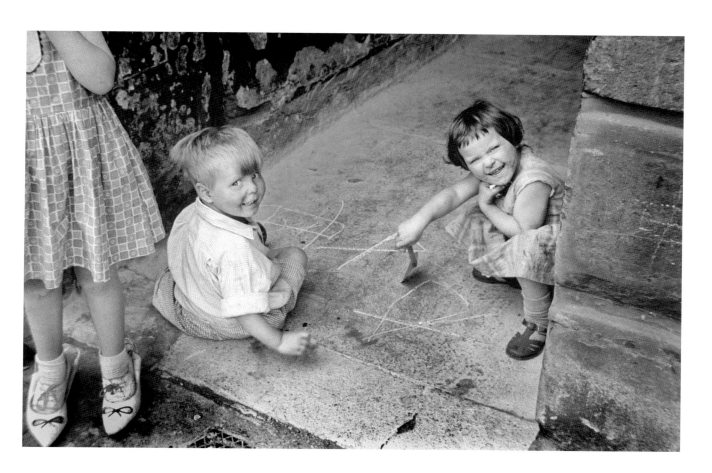

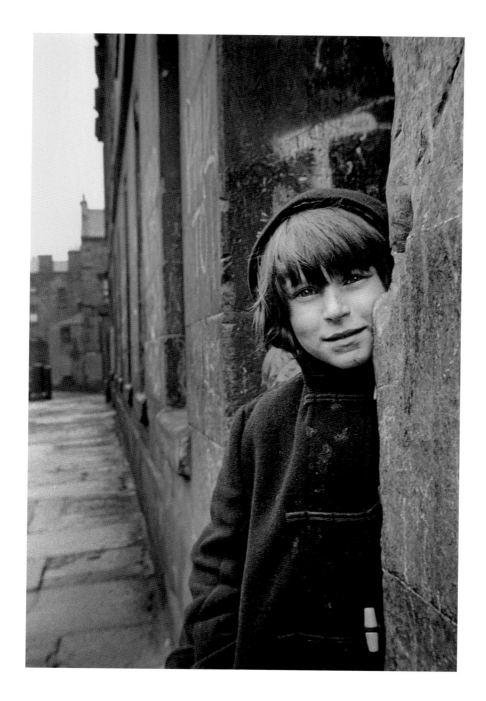

Boy, Maryhill, Glasgow

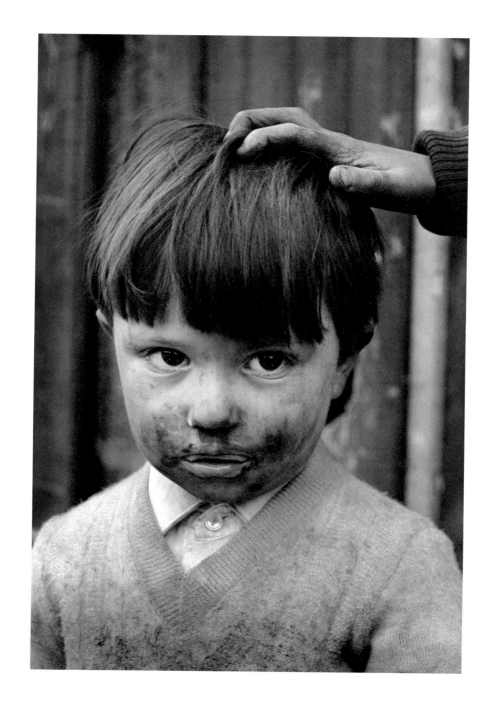

Comforting arm, Gorbals 1968

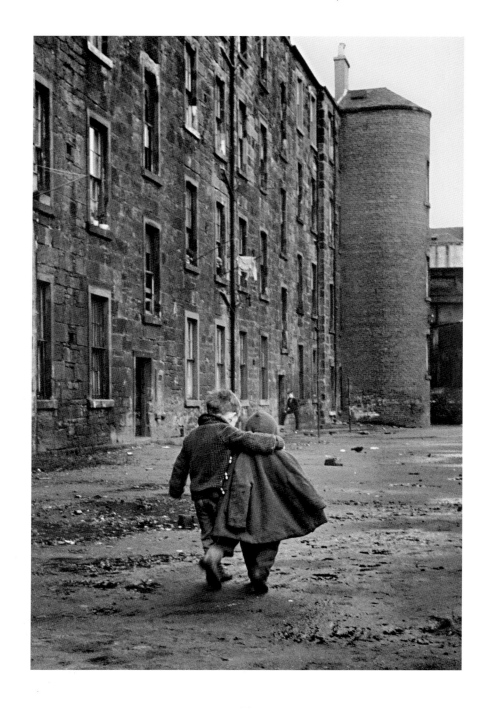

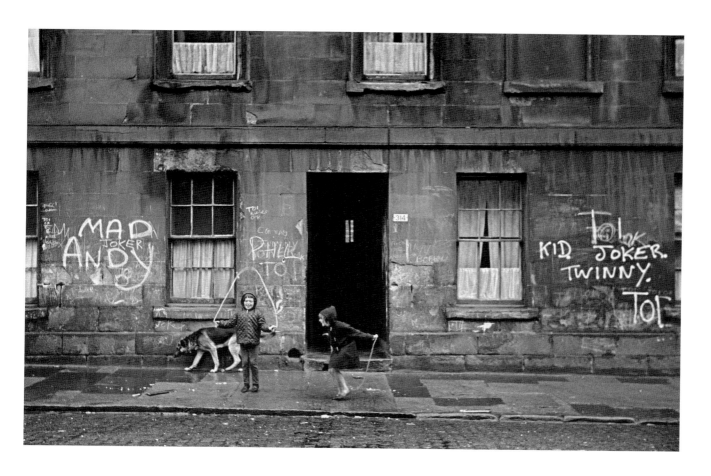

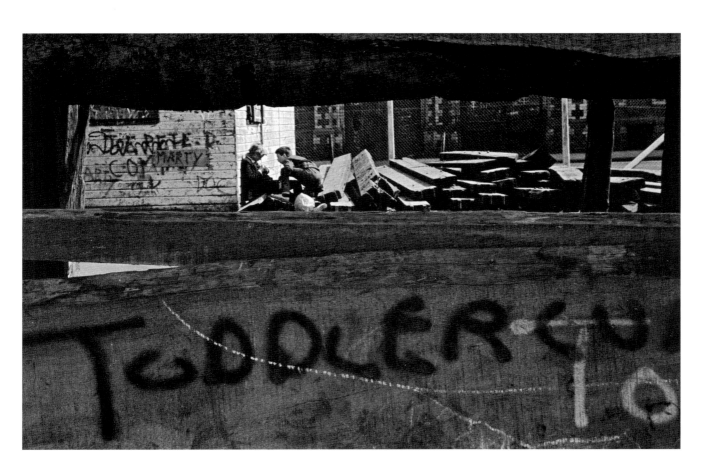

Tradeston, Glasgow

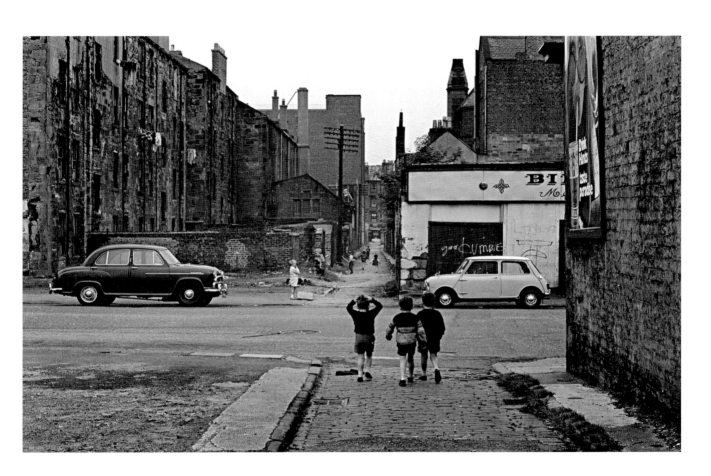

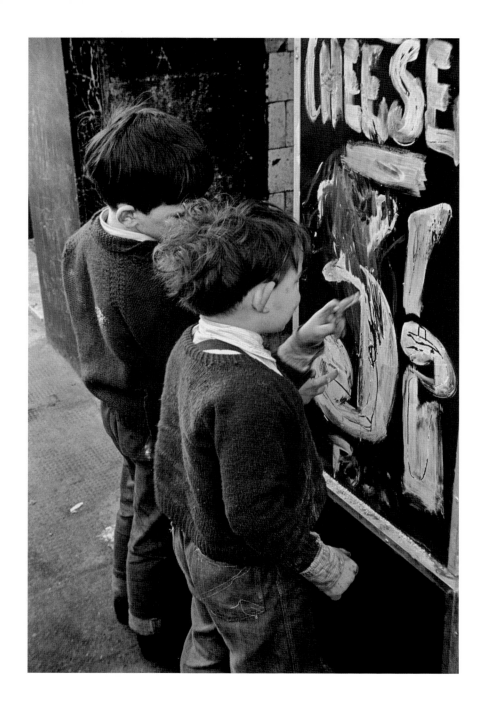

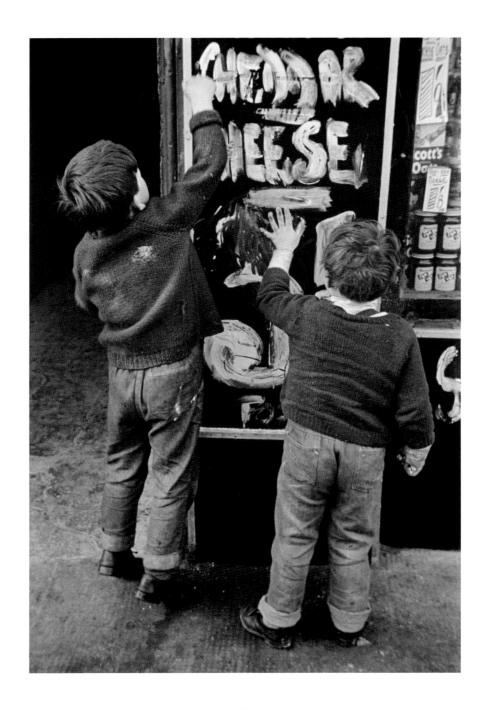

Paintstore, Maryhill

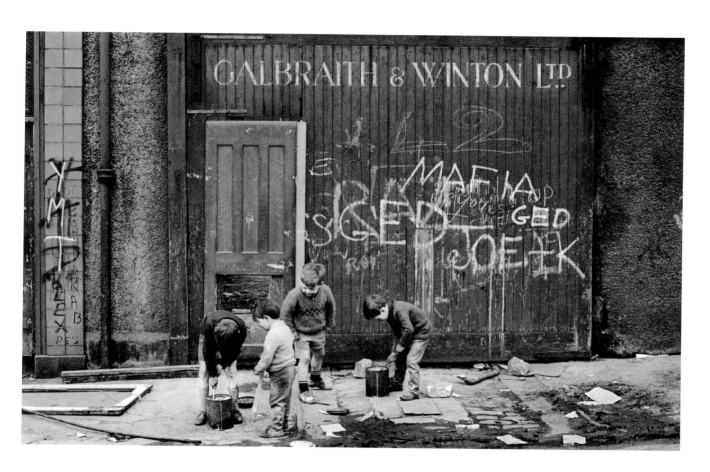

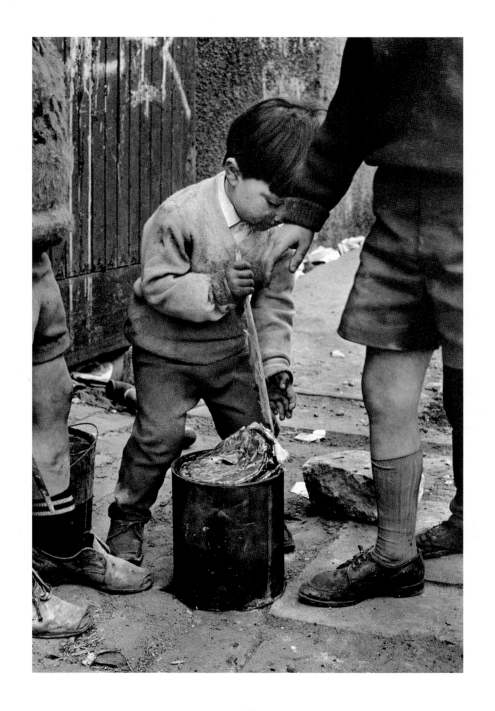

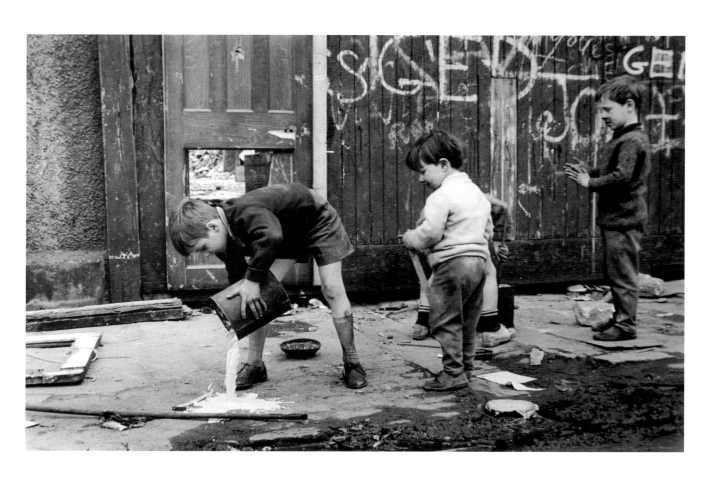

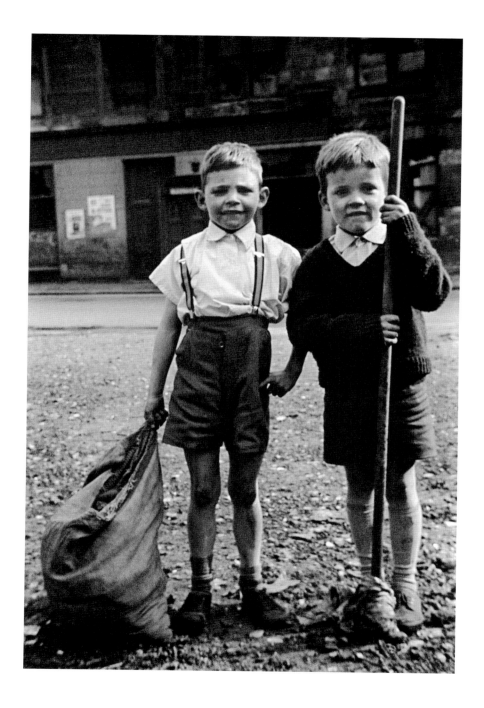

Saltmarket, Glasgow

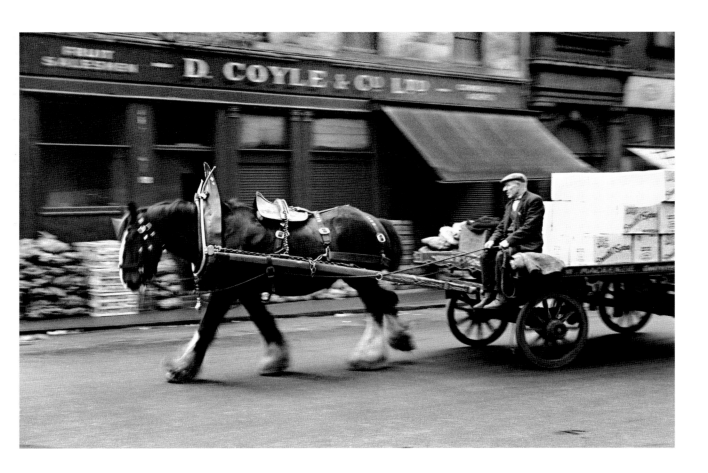

John Macaulay, barrow boy

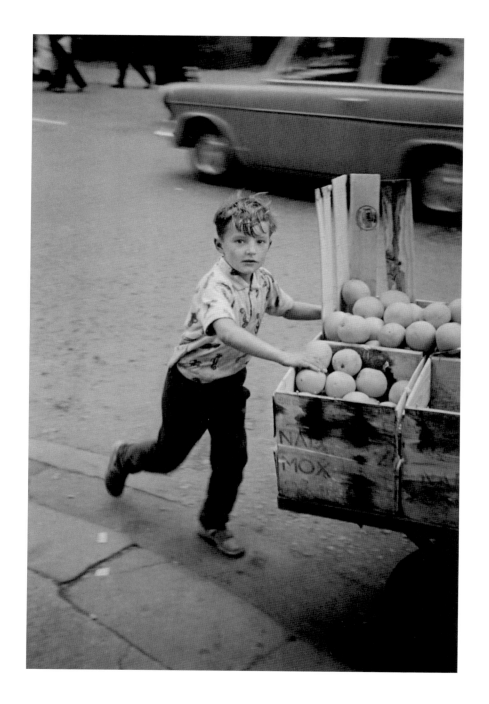

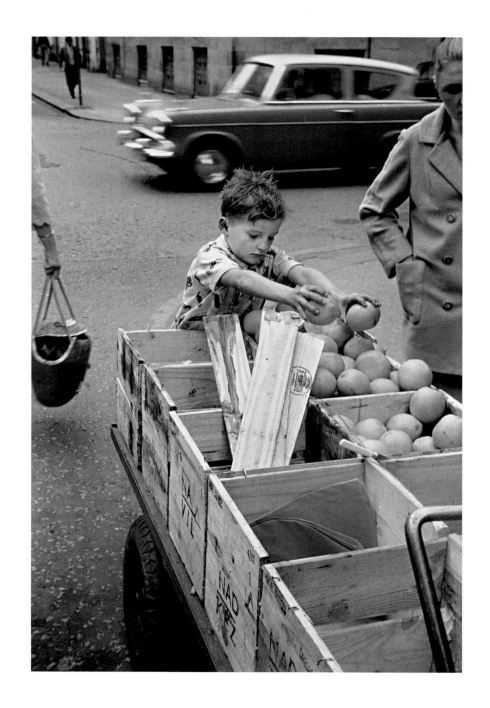

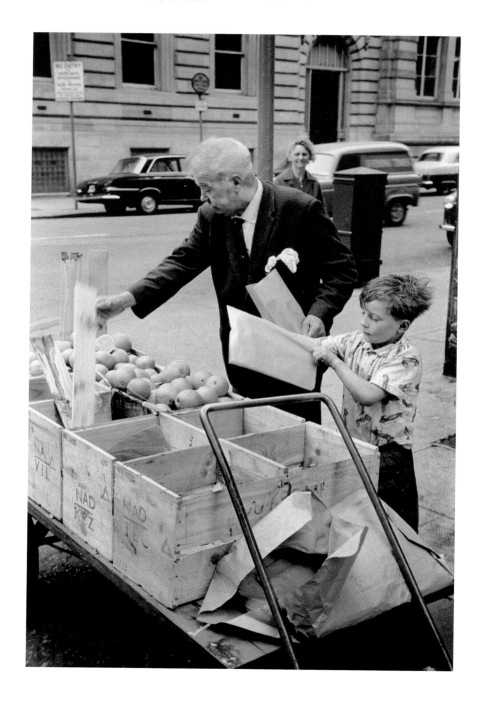

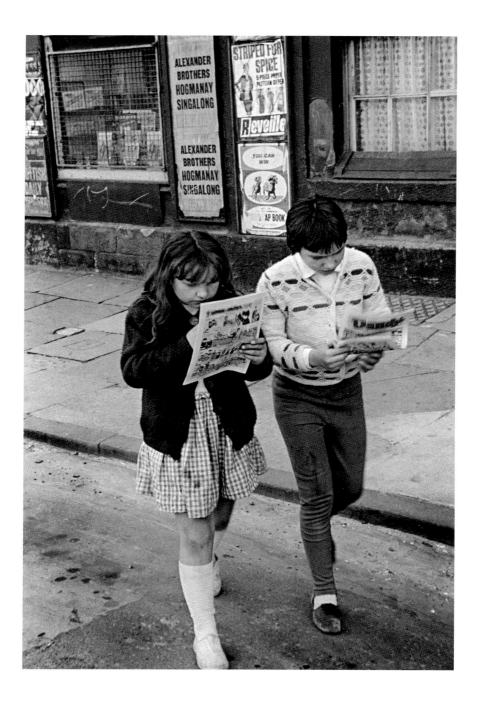

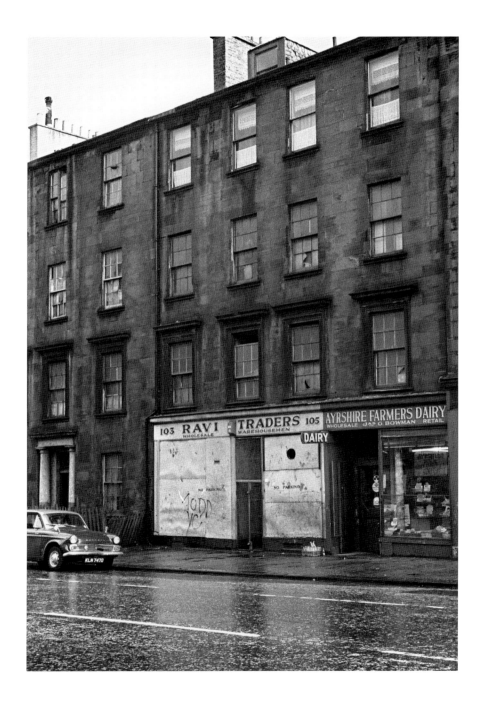

Gorbals girls

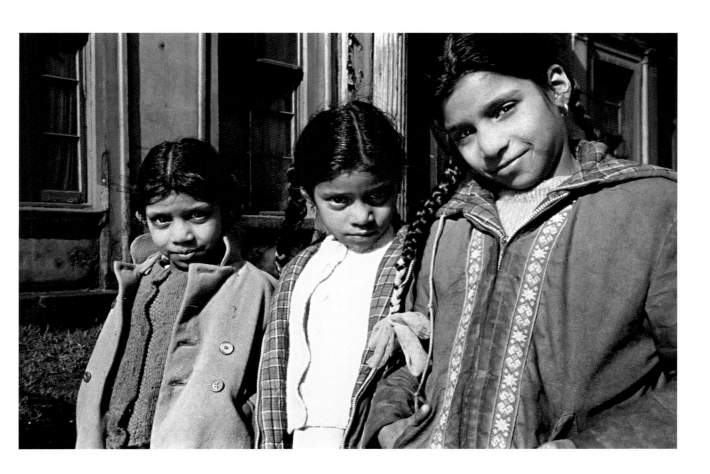

Gorbals boy

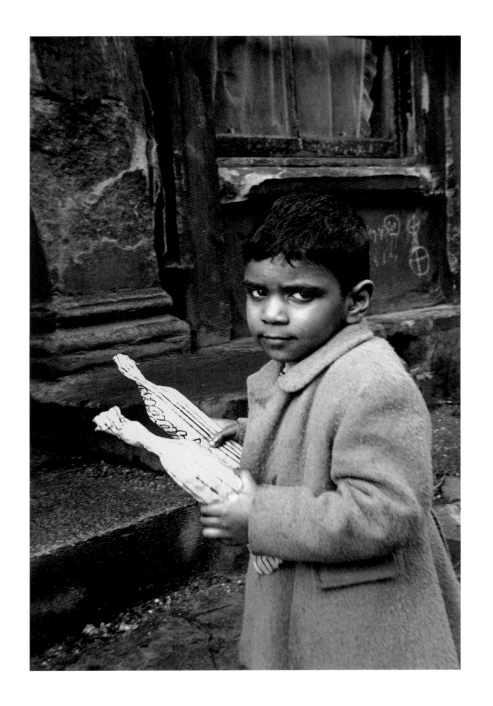

Cowcaddens, Glasgow

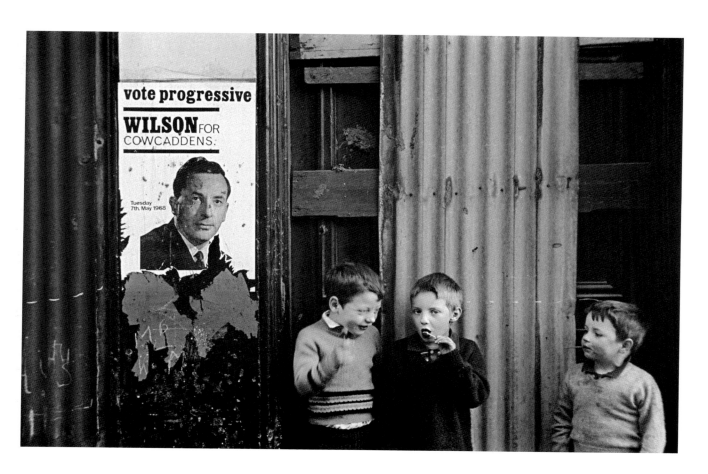

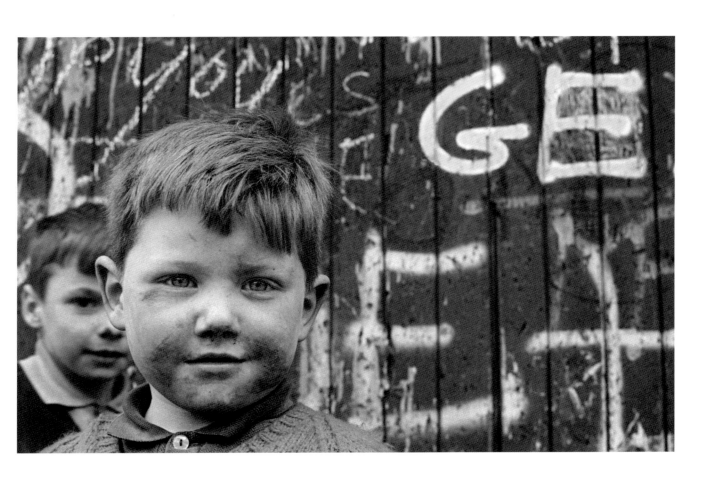

Musical Theatre, St George's Cross, Glasgow

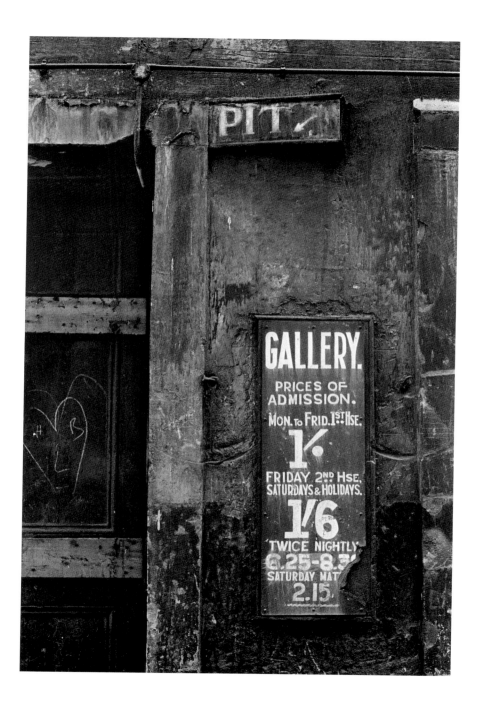

Maryhill

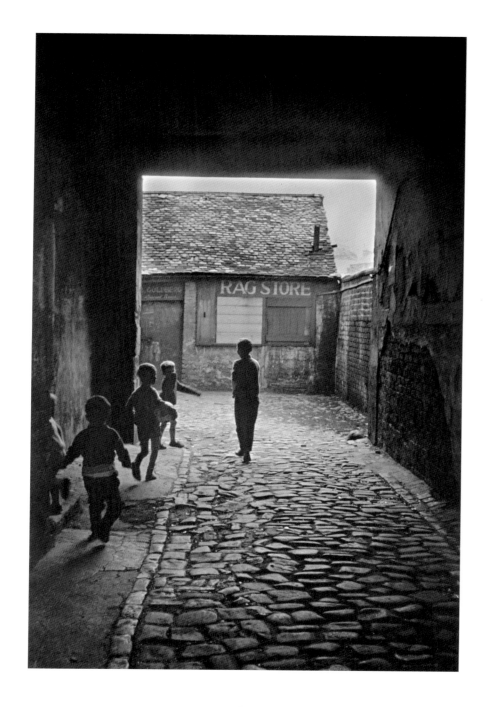

Gorbals

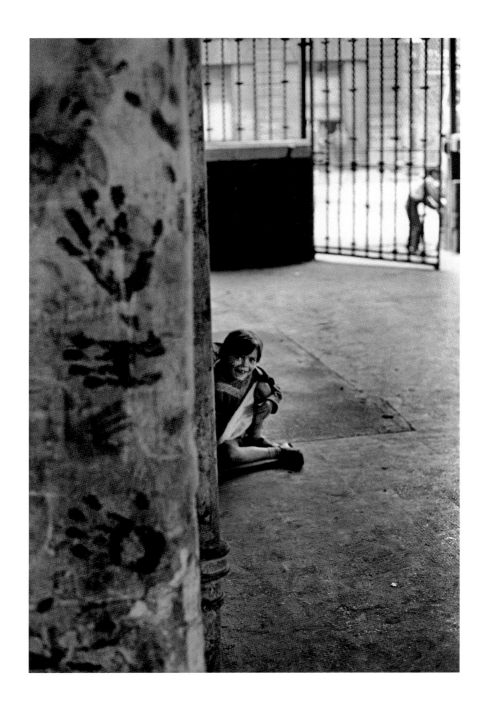

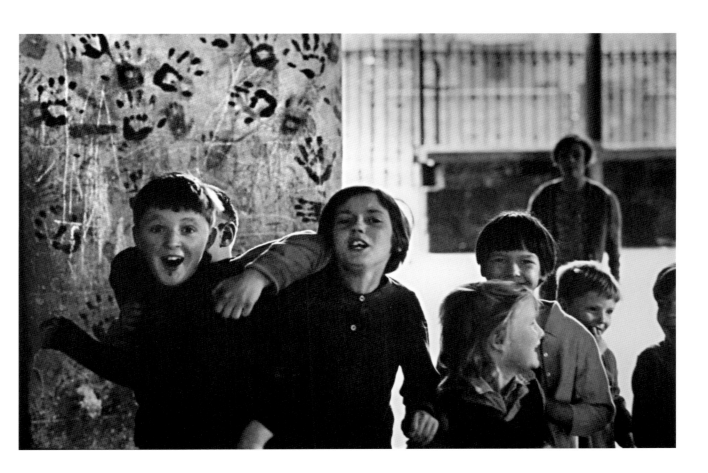

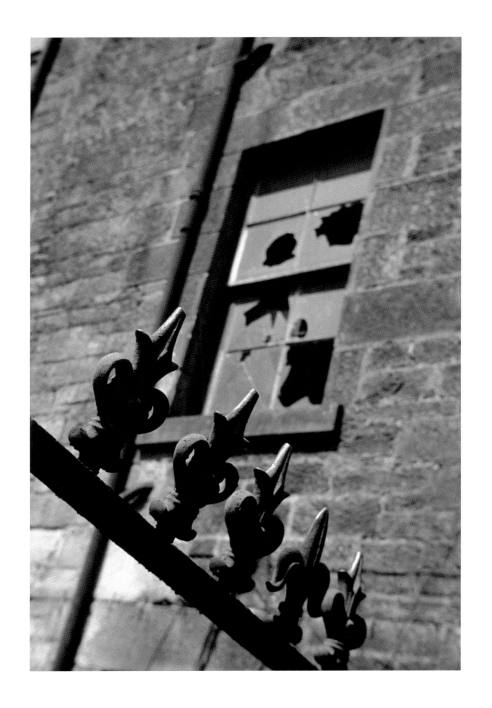

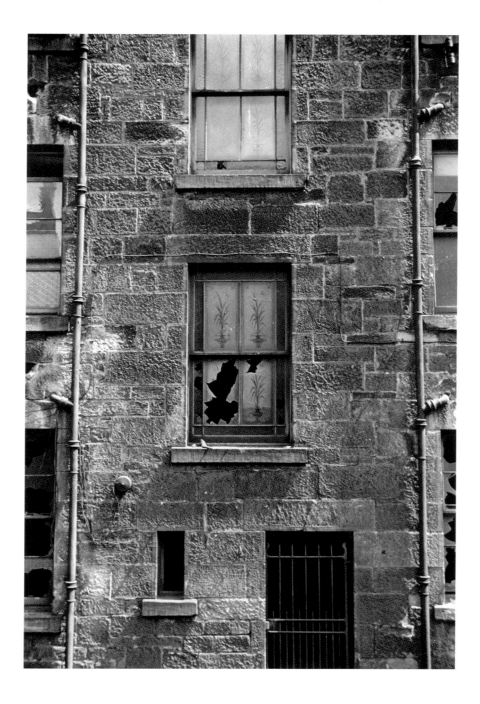

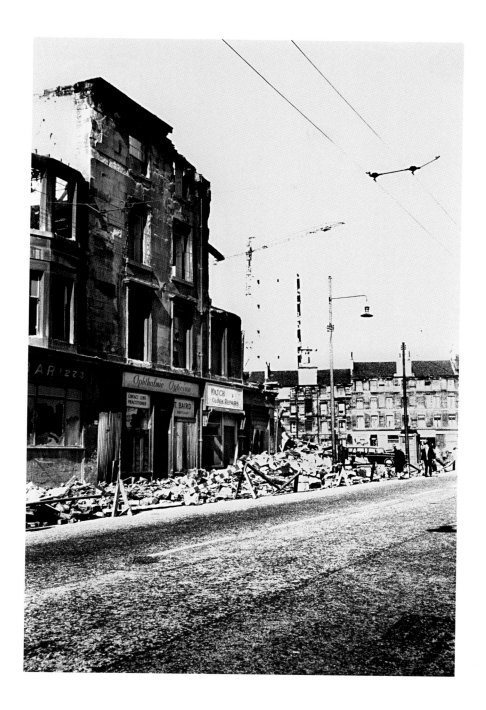

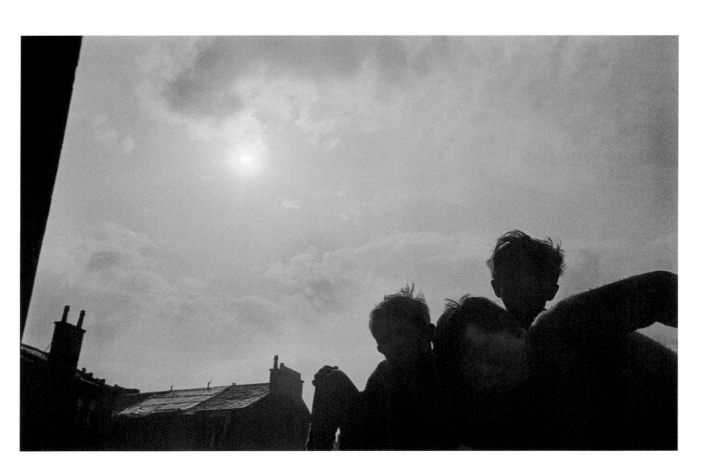

New living, tower blocks, Saltmarket, Glasgow

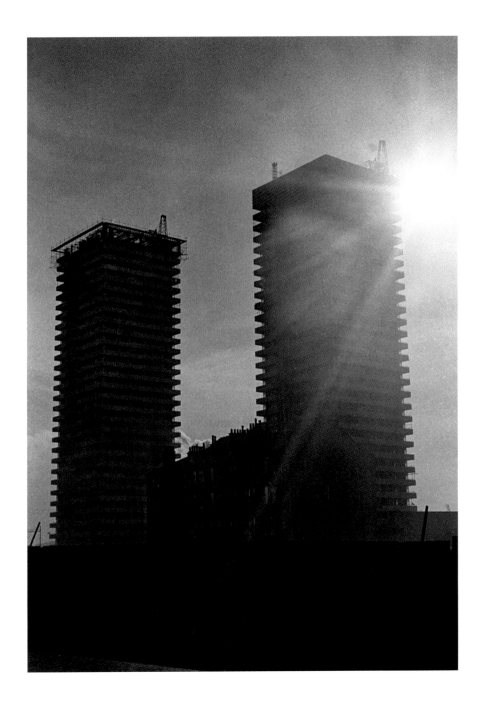

Afterwords

The Glasgow which I photographed in 1968 has long gone but the sounds, sights and smells of that time still exist in the recollections of those who lived as children in the streets and back courts of Gorbals, Tradeston, Maryhill, and Cowcaddens. For those children, now men and women in middle age and beyond, the black and white pictures in this little book can still sharpen the memory as no other medium can.

For the rest of us, we see the charm masking the poverty, the play surmounting and even capitalising on the dirt, the physical evidence of community in inevitable decline and we pity and regret the circumstances - but not the people. We admire them.

What became of them – the thousands decanted to the new estates, new towns or the tower blocks? Drumchapel, Cumbernauld, East Kilbride and Glenrothes may have given many of them new clean environments and better prospects for life. But the others?

Go back a page and look at the last picture. As this book goes to press, those very towers, the symbols of the new Glasgow, are themselves going the way of the old tenement in the foreground and in turn are facing their own demolition. Forty years from now, will anyone regret their passing and seek memory of them in photographs? I doubt it.

David Peat

David Peat 1947- 2012

Film-maker and Photographer

I owe David Peat so much when it comes to the style of reality/documentary filming I have been doing over the past few years. The relaxed presentation, the readiness to change the subject at the drop of a hat when a likely situation arose and the lack of TV cliché 'walk and talk' style of doing things; I learned it all from David and Murray Grigor in those films which seem like yesterday, although they do go back a wee bit! The main thing I learned from David and Murray is that you mustn't lose sight of the fact that it is supposed to be fun, in that we are all very lucky to be doing it. If you can manage to get those feelings to come up the lens then you have got it made. David never failed, in my experience, to do just that. I'm glad to have had the privilege of spending time with him, back in the early days, and recently in Blackpool during my tour when he came to interview me as part of his television retrospective of his work. It was years since we had met, but we picked up the conversation exactly where we had left it off all those years ago.

In all those years I had no idea that David was such an accomplished stills photographer. It was while he came to see me in Blackpool that he presented me with a lovely collection of prints which he had done since he was in his early twenties. They absolutely took my breath away. They are on a par with the great Oscar Marzaroli when it comes to capturing the mood of an era. He has managed to make us take stock of what Glasgow was like in the sixties. At some points it manages to look as if they were taken in the thirties! How he manages this I will never know, but, such is the way of natural genius. I shall miss David, and so shall Scotland.

Billy Connolly